In Him was life; and the life was the light of men John 1:4

# MAKAIRA

## The double edged sword

### *Olutosin Ogunkolade*

authorHOUSE®

AuthorHouse™ UK Ltd.
500 Avebury Boulevard
Central Milton Keynes, MK9 2BE
www.authorhouse.co.uk
Phone: 08001974150

All characters in this book are fictional. Any resemblance to any person living or dead or any place is unintentional and purely coincidental.
This book has not been written to promote any doctrine or as a theological text, it is purely for entertainment.

First published by AuthorHouse      03/25/2011

ISBN: 978-1-4567-7711-1

Any people depicted in stock imagery provided by Thinkstock are models, and such images are being used for illustrative purposes only.
Certain stock imagery © Thinkstock.

This book is printed on acid-free paper.

Because of the dynamic nature of the Internet, any web addresses or links contained in this book may have changed since publication and may no longer be valid. The views expressed in this work are solely those of the author and do not necessarily reflect the views of the publisher, and the publisher hereby disclaims any responsibility for them.

# Dedication

To everyone who will read Makaira . It is all because of you, it has been worth it.

# Acknowledgement

For everyone who has contributed to make Makaira ready and available in due time I am grateful.
And all those who have encouraged, supported and believed in the publishing of Makaira, Thank you.

# Contents

# Introduction

The book you are reading is an inspired combination of revelation and fiction, it is about a people and their deliverance, it is about leadership and spirituality. It is my hope and wish that it will serve the triple function of entertaining, enlightening and igniting the use of creative imagination.

# Chapter 1

# IN THE BEGINNING

It is a dispensation in that part of eternity set apart for the use of man, savage forces have been deployed from that dark realm beyond human reach. Their target is the great continent .

For too long the great continent has been bound, dishonoured and oppressed. It is that great land of many countries from that angle where the sun rises called Africa. On this particular day something unusual is going on, there is a sign in the sky above and it is very conspicuous.

This sign is evidence of a great happening in the heavens above western Africa.

The discerning, those that 'see', and star gazers can sense an unusual happening in the skies above them and a feeling of euphoria on the earth on which they stand. A great portal has opened in heaven which signifies the birth of one who is to be great on the earth, one who is to be a hero and a deliverer to his people, for in every generation it is the purpose of the Divine also known as Three to raise deliverers to the oppressed nations.

As the forces that take on flesh from the dark realm known as Horns, Nephilim and Apollyon continue to criss-cross the great continent with their cohorts they are oblivious to the plan of the Divine known as Three to deliver the great continent. Only those washed in royal

blood called the sons of the covenant are immune from the works of these dark forces. The dark realm never know at the right time what Three is doing.

In the western part of Africa, on that great land called Nigeria where the Niger and River Benue rivers flow and meet together forming a confluence, Olaniyi Benjamin chosen by Three to be washed in royal blood is to be born.

The three spirits Horns, Nephilim and Apollyon have unique assignments each . Horns is the principality responsible for political oppression and pride in some leaders of the great continent, Nephilim is the fallen angel of corruption with the task of seeing to it that corruption and perversion thrives among the people and in various areas of the great continent, while Apollyon who is the vilest of them is the prince of the bottomless pit with the responsibility of seeing to it that the great continent remains stagnant, backward and unrecognised among the committee of nations.

But there is hope for the great continent, the power of hope cannot be suppressed or denied. No, not for long.

Exactly seven months after the event that took place in the heavens above, it is seven thirty pm, a young man called Yemi and his beautiful wife Elizabeth are taking a walk, it is a Saturday . She is five months pregnant . It is the cool of the evening. The sky looks clear, they are at a picturesque and hilly environment in the ancient city of Abeokuta a suburb in Ogun state in the western part of Nigeria. They are both of Yoruba extract.

Yemi is telling her a story. He has always been a good story teller who knows a lot about world history, African tales and legends and Elizabeth delights in hearing them. He enjoys telling her stories, Elizabeth delights in listening to him. He is the youngest son among five boys from the Benjamin family, he and Elizabeth have come a long way from their high school days where they were sweet hearts, theirs seems to be a match made in heaven. Romeo and Juliet's relationship is no match to Yemi and Elizabeth's love affair it seems, that's what people tell them.

Elizabeth has always felt comfortable and secure in Yemi's presence. She has her hands wrapped around his bulky right arm, Yemi is no stranger to the gymnasium. He is telling her about the legend of the

candle, it's a short story written by Paul Bailey, as they walk they glance at each other now and again, their body language shows mutual affection while their steps are taken at the same pace. Suddenly, something captures Yemi's attention and he goes silent suddenly. They notice there is a star in the sky and it is the only one up there,

as soon as they set their eyes on it it seems to twinkle more brightly as if the star is signalling its awareness to their observation of it and it vanishes a few seconds later.

They look into each others eyes in surprise and continue their walk, they take a couple of steps and notice ahead of them are two young men who they did not notice earlier. It seems these guys just appeared out of the blue, Elizabeth thinks to herself, they are tall and good looking men arrayed in white long sleeved shirts and white trousers, even their shoes are white. Their golden coloured belts shine with a powerful brilliance. These men seem to have a glow about them.

Yemi leans over to his wife and whispers in her ears 'Obviously these guys must be strangers here maybe they are trying to locate the traditional king, the 'Alakes' palace. After all they look like royalty themselves' . As they move closer to the men they notice one of them has long dark Caucasian hair of shoulder length and the other man has a golden coloured afro, like an African. They both look beautiful.

'Be blessed of the most high, the all knowing' says the man with the afro. Yemi asks the strangers who they are.

'May that tender plant in your womb grow to fulfil destiny and release greatness' said the man with the long hair. Where are you guys from Elizabeth asks.

I am Aseyi replies the man with the golden coloured afro and i am Sirael says the man with the long hair. They both chorus at the same time 'we are divine messengers from the most high but fear not we are not here for judgement or battle but to bring you good tidings for that tender plant in your womb is a special one sent to liberate this great country and the continent of Africa from enslavement and oppression. We are here to supervise his growth and development, we will be his ministering spirits all through his life on earth and at

the fullness of time he will be trained in the ways of makaira and born of the Blood that he may be one of the sons of the covenant'
Are you angels from God? Yemi asks in his usual inquisitive manner . The angels speak at the same time in a very majestic tone, 'Yes we are. The reason two angels have been sent to you and your wife is because two is the number of witness, in due time when the seasons come together all we have said to you will happen. Name him Olaniyi'.
Both men disappear at the same time after delivering their message.
The Benjamin's did not continue their walk, having an encounter with angels was the least of their expectation. They went home quietly but somewhat nervously to ponder on what the celestial visitors have just told them.
Life goes back to normal for the young couple weeks after the initial shock and anxiety that followed the angelic visitation which they never told anyone about.
Time passes and the seasons are due for the arrival of the man child prophecied by the angels to the Benjamins, but strange happenings began to take place on the earth especially in Nigeria before the birth of this child.
In some of the nurseries across Nigeria, child care workers claim to see all kinds of images. Many see ghosts in baby rooms which look frightful, a few of them appear in the form of spiritual bodies that have no heads. They would appear and disappear at odd moments and there are situations of unfortunate injuries and death to babies and children in households, nurseries and day care centres in Nigeria. It is reported in major newspapers that light bulbs are switching on and off without being controlled by any visible individual in child care centres and households across Africa. It is also a time of major political upheaval across the globe and misfortune to the young people. The unfortunate situation of ritual killing was on the increase all over Africa especially the ritual killing of toddlers.
This continued for a period of four months. The hearts of men begin to fail them and great concern came upon all religious and political leaders in the nations of the earth. The worlds is in a financial

recession with suicide and suicidal attempts on the rise among people.

But someone in the metropolitan city of Lagos understands the times and happenings.

Bishop Thomas Cedric is a wise and elderly man who has devoted over fifty years of his life to evangelism and community service in Nigeria. He has made the city of Lagos his home and ministry base, he is of American parentage and birth. The bi- spectacled clergy is an articulate teacher who often operates in the prophetic, he is a man who understands the times and the seasons as revealed to Him by the most high, the Divine. After all he is the servant of the Divine.

One cold night while having a cup of chocolate tea he is having a discussion with his young assistant Julius about the state of the world particularly Africa .

'I prayerfully looked at the stars yesterday night Julius'. The stars? asks Julius . Yes the stars replied Bishop Cedric. I needed direction and understanding of what is happening in our land and our world. What do the stars have to do with what is happening on earth at this time asks Julius.

'You have a lot to learn my young protégé. The stars we see above us are not just mere luminous bodies, there are parallels between the Words of the divine in the Book, the stars and the happenings on earth. The hand writing of the divine is in the stars, our history, what has happened, what will happen and the things the divine has destined for us as individuals can be seen in the stars. Have you ever wondered why some of the things psychics and mediums tell people happen'

I have always thought astrology itself is evil, the naming of stars and consulting them replied Julius.

'My young friend, astrology can become evil depending on how you access it. It is not evil when you go through the Door. If the Spirit of the divine gives you access to it then it is not evil but it becomes a valuable science, for astrology is the science of the heavens. It is written your will be done on earth as it is in heaven, the second person among the Divine is the Door. He tells us in the Book that He is the Door, so He is the door to all knowledge.

Astrology is a science given to man by the Divine so that man will have some access to His ways but the sons of the covenant have not looked into it and used it due to fear. The Book tells us in the nineteenth chapter of the book of psalms that the Divine know all the stars by name, The Divine named them individually because each of them are significant and have an importance.

You must not forget that the men the Book refer to as wise who visited and presented gifts to the baby, the God man who eventually bled on the cross were star gazers or astrologists. In the times of the Book, astrology was one of the sciences that was studied by people, even in the institutions of learning .

If you follow and obey the words of the Book it is like following the blue print of what is written about you in your star. What is written about you in the heavens is what manifests in your life if you follow the instructions of the Book'

You are very wise replied the young protégé. All true wisdom comes from the Divine replied Thomas Cedric. 'I saw by a spiritual opening of my eyes that this country is in very significant times, someone with a special assignment has been born or is about to be born in these times who will be significant to the liberation of Nigeria, of Africa and he will have international influence. The dark realm have realised it but they do not know where the birth is taking place though they have an idea of the season, that is why there has been a lot of misfortune among our young people. The leader of the dark realm, that fallen spirit being who was glorious in his heavenly angelic days is out with his cohorts trying to prevent this great event. He can discern, his strategies and ways are still very much the same. We both know that in every dispensation when a deliverer is about to be born there has always been upheaval, death and misfortune among young children'

It is late into the night, Thomas Cedric and Julius say a thirty minutes prayer for the country, the great continent, themselves and the world before going to bed.

Fast asleep on his comfortable giant sized mahogany framed bed with books, concordances and the Book by his side Thomas Cedric has a dream where he is caught up to a beautiful land no eye has seen or ears have heard of . In this land he has encounters with

genies, talking beasts, strange looking dwarfs, fauns, centaurs and giants.

As Thomas Cedric takes his first steps in this awe inspiring land, a tall and strong looking centaur walks towards him. Hello Thomas says the centaur as Thomas Cedric moves back in surprise, 'i mean no harm my friend you have been scheduled for this visit because you have an important assignment on earth for the Lords chosen who will be born shortly in the nation of Nigeria . My name is Sag and this beautiful land in this corner of the heavenly realms is called Cirsqua. I have been chosen to take you around and get you acquainted with him the Lord has appointed to deliver messages to you. Be rest assured we are all friendly and i will see to it that you get back to your realm safely'

A supernova is in the sky above beaming radiantly. It is the only one in Cirsquas sky and it seems to provide the warmth and energy Cirsqua radiates.

As Thomas and the seven feet tall centaur walk on the lush green vegetation before them a refreshing and gentle breeze blows in their direction, it seems to be some form of gesture welcoming Thomas to Cirsqua. It comes from the direction of a tall imperial figure standing on an imposing square shaped mountain about fifty miles away. The well structured man on the mountain looks glorious and majestic.

Thomas looks in his direction and asks who he is. Sag responds 'That is the darling of heaven the very one whose face lights up the heavens and eternity. He is the second personality in the Divine Three, you may call him Jesus' . As Thomas looked away from Sag to the square shaped mountain Jesus had disappeared. Thomas is curious and excited. I just saw Jesus he wispers to himself in awe ! As they walk along, friendly giants wave to him and say hello, genies come out of their lamps in different shades and colours, four face dwarfs, two face dwarfs and one face dwarfs all come around in their varieties. Thomas does not need an introduction, they all know his name. In Cirsqua everyone knows one anothers name.

As Sag and Thomas walk on he could not help but wonder at all he is seeing, how great is the wisdom and manifold the works of God the Divine he whispers.

There is a warmth, an energy and beauty about Cirsqua, Thomas has never seen anything like it. It is a perfect environment where the grass does not wither, the plants do not die and there is no litter. The architecture of buildings in Cirsqua are masterpieces the type not found anywhere on earth. All the flowers of the ground are alive, singing soothing and sonorous worship music as they sway from the right to the left with rhythm in their various varieties. There is no night or day in Cirsqua but perpetual light. The grass of the ground do not wither, the moment they are stepped on they bounce back to their normal position as if nothing happened to them.

Thomas asks Sag why this part of heaven is called Cirsqua and Sag tells him it's because almost everything in this part of heaven has the shape of circles and squares, from the shape of the mountains to the shape of the fountains, buildings and layout of the land. Probably circles and square shapes are the favourite shape of the Divine, the Godhead.

As they walk on they come to a beautiful and gently flowing river, a huge bubble rises out of this crystal clear river and engulfs them lifting them up high to the very heights far above the mountains of Cirsqua where Thomas and the centaur can have a clear view of the whole land. The scenery is breath taking . Distance away are creatures of all types not seen before on earth. Thomas Cedric can see fauns in their own community.

Lights of various colours are seen across the beautiful regions of Cirsqua, all the different colours of the rainbow are seen in it . There are trees in it with multi-coloured leaves that glow and produce its own unique light around its region while some trees produce up to twelve manner of fruits each. Thomas Cedric sees eagles and hawks flying around swiftly and orderly in the sky . They look a lot like the ones on earth but they are much larger and they have multi-coloured feathers, each feather of these hawks and eagles is differently coloured, all the colours found on earth is found on the feathers of these birds and perhaps colours we have not seen on earth before. They glide gracefully, they are indeed masters of the sky.

He notices some phoenix that fly around from time to time blazing the sky with a different shade of colour. They seem to be involved in

some kind of play, they are having fun, he can tell from the way they interact and coordinate themselves. They are a beauty to behold! Within the bubble there seem to be a cooling effect, it is very comfortable. It lands Sag and Thomas Cedric on the front lawn of an imposing palace where angels and translated human souls live. Over the palace is a rainbow. Around that palace are all kinds of aesthetically beautiful buildings, some are large while some are smaller. Sag and Thomas Cedric proceed towards the building, the bubble disappeared as soon as they stepped out of it.

Angels and human spirits in various places say hello while others are distance away going about their business. Somehow Thomas can differentiate between human spirits and angels, but wanting to learn from Sag he asks Sag what the difference is between angels and human spirits. Sag tells him all angels have the touch of God upon them as well as human spirits but angels do not have the DNA of God within them like human spirits do. Human spirits are superior.

A short distance away are unicorns dwelling in their territory, gazing on lush green grass, they are such majestic and pure looking creatures. The run with extreme speed and glide swiftly.

A friendly looking angel in a pure white flowing garment steps out from the palace to welcome Sag and Thomas Cedric. 'Welcome friends, i have been waiting' They all step into the building which is lavishly furnished and sit on beautifully made furniture that is 'alive' and the furniture 'warms' up to them making them feel very comfortable. The angel entertains his guest with angelic food, manna and some drinks. Quiet heavenly music permeates the air around them while the angel tells Thomas Cedric the plan of God for the continent of Africa, Gods plan for Nigeria and what manner of man Olaniyi Benjamin will be, Gods presence in his life, and Thomas Cedrics role in his life and what steps Thomas Cedric should take for his own ministry, Thomas Cedric had a lot of questions to ask. It is a long conversation after which the angel brings out a bottle of oil and gives it to Thomas Cedric. 'You must anoint Olaniyi with this special ointment . As you pour this bottle of oil on his head during his naming ceremony the Spirit of the Lord will be upon him from that day forward'.

Time seems to have passed by so quick my friends, it is dawn in your realm and we want our earthly visitor to be home in time so Julius does not get worried said the angel. Thomas Cedric doesn't feel like leaving Circqua but he understands he has an assignment on the earth to carry out.

The centaur and the angel walk Thomas Cedric to the front of the building, as the Bishop walked down the stairs, and steps on the ground he supernaturally transcends back into his body on the earth.

He wakes up breathing rapidly, he looks at the clock on the wall to his left hand side. It is six thirty am. He thinks he had a mere dream but the little bottle of oil the angel gave him was on the bed beside him, it was not a dream after all.

He is happy his wife is not around, she has travelled to the United States to visit their son. He cannot have an encounter like that without his wife realising something happened. She would get worried and unusually inquisitive.

# Chapter 2

# EARLY YEARS AND PROCESSING

In the metropolitan city of Lagos in an ultramodern and private hospital building in Ikeja the Capital of Lagos State in Nigeria, a beautiful lady travails in child birth. It is Elizabeth Benjamin, Yemi's worthy consort. She is due for the delivery of the man child. It is a Friday, the eighth day of the eighth month of the year two thousand and eight, the seasons have come together and the words spoken are about to become manifest for it is words that become things.

She is in a two hours labour. Yemi, a doctor and two nurses are around to aid her delivery. Her husband has his hand placed in the palm of her right hand while he speaks words of encouragement into her ears and constantly kisses her on her cheek encouraging her to travail as the doctors instruct her to push.

Suddenly two diabolical looking beings sent from the dark realm appear in the delivery suite to cause complications and death to mother and child, they are not seen by anyone because they are invisible to the natural eye, they walk towards Elizabeth and point their index fingers at her. Almost immediately an invisible and bright ray of light appears about three feet away from Yemi, two glorious angelic beings step out of the light with double edged swords. It's Sirael and Aseyi, they walk up to the unwelcome visitors and strike them with their swords. Instantly the visitors from the dark realm

scream, turn into black dust and enter the ground. The guardian angels with their swords by their sides each stand calmly beside Elizabeth's bed one to the right and another to the left supervising her delivery, exactly five minutes later she brings forth the baby boy, his cry fills the delivery suite. It is eight pm on the dot.

It is an emotional moment as the young family cuddle, exchange kisses and shed tears of joy. Congratulations and good will pour in from the doctor and hospital staff, even the angels are smiling.

Sirael and Aseyi both point their index fingers at the babys head, rays of light shine from their fingers, the rays meet over the baby's head forming a golden halo while he is positioned on the laps of his mother.

Three days seem to go by so quickly, Elizabeth and her son are given a clean bill of health and discharged from the hospital. Yemi was there to pick them up.

He is happy to have Elizabeth back home, they recently relocated to the city of Lagos from the ancient city of Abeokuta. They have always liked the idea of having their children in Lagos, that is why when Yemi's transfer letter came informing him that he has been transferred to Lagos it was a welcome development for the young couple.

The weather is hot and sunny as the sun shines brightly, there is some traffic on the way home. Elizabeth and her son are comfortably sitting on the back seat while her husband drives. While waiting in traffic the words of the heavenly messengers keep playing in Yemi's mind 'and he will be trained in the ways of makaira'.

At home the Benjamin's sit down to dinner, their new born is fast asleep in his cot as they discuss recent developments in their lives, their plans for the future and past happenings. They reminisce about their encounter with angels, the prophecies and the name the child should be called.

Yemi says to his wife, as the angels instructed us we will name him 'Niyi but his full name will be Olaniyi. As you are well aware most Nigerian names have a prefix to it .It means our child is a valuable person, he must be a bringer of success and good fortune to many people. Yes, yes Elizabeth replied i truly like the meaning of that name.

They both agree it was about time they start attending one of the local churches around, they were both brought up in the Christian faith but have not been going to church since they recently relocated to Lagos. They both want a reputable clergyman playing a part in their sons naming ceremony. The couple have always noticed a particular glossy sign board publicising a church called Miracle House, it has always caught their attention and they consider becoming members of the church. Whenever they drive by they notice it, it says 'Your welcome to Miracle House, expect a miracle!'

As they discuss and deliberate on these, the two angelic beings Sirael and Aseyi watch closely from a distance. Yemi stays up late into the night listening to rhythm and blues music and pondering on what the future holds for him and his young family while Elizabeth went to bed early.

The next morning a Friday, he decides to check out the church. He makes his way down to Miracle House before heading to the nearby super store to do some shopping. He hopes to enquire about the church and the requirement for having a clergy man to conduct his sons naming ceremony which he intends to have seven days away. He parks at the church's parking lot and makes his way towards the reception and presses the buzzer, a soft spoken lady opens the door. She is light skinned, meticulous and decently dressed. She lets him in and gives him a seat after asking him if he has an appointment and how she could be of help. Her name is Mary.

The reception is fully air conditioned, clean and comfortable. Yemi waits, sitting comfortably on the only sofa in the reception while Mary goes off to get the appropriate person to speak to him, about five minutes later she walks in with Julius.

They shake hands, get acquainted and Julius takes the time to answer Yemi's questions about the church and its mission and takes him on a tour of the church facility. Julius invites him for their nine o'clock service the following day and he agrees to attend it as he was leaving.

Later that night at the dinner table in the beautiful and modestly furnished flat of the Benjamin's, Yemi tells his wife what he thinks about the church, its environment and why he wants he and his family to attend service there the following day, a Sunday. While

the conversation is going on the angels Aseyi and Sirael stand by watching over the Benjamin household quietly . Baby Olaniyi is sleeping peacefully in his cot.

In the morning, shortly after breakfast the couple get ready for church service, but while they are getting dressed, an invisible but dark shade of light shines out of the ground. Out of the dark shade of light steps out two demons who look like twins, they are identical and they both have bow and arrows. 'Lets shoot arrows of sickness at the man and his wife, if they fall sick instantly they will not make it to church' they say to one another.

One targets his arrow at Elizabeth while the other targets his arrow at Yemi . They shoot their arrows, the arrows pierce through the air with rapid acceleration but each arrow fell to the ground an inch from its intended target. The twin demons are amazed and look at each other in surprise, as soon as they look in the direction of their intended victims they see two large golden shields; one is protecting Yemi and the other is protecting Elizabeth. Written in front of each shield is the word Faith. Behind the shields are the angels Sirael and Aseyi, Aseyi is protecting Elizabeth while Sirael is protecting Yemi. Each of the angels pull out a double edged sword from his mouth from his mouth and walk towards the twin demons who begin to panic. The shields disappear.

The baby Olaniyi started crying loudly at that moment, he can feel the vibration from what is going on and his mum hurries to calm him. The angels strike the demons, they scream and vanish into thin air. The Benjamins make it to church.

The service turned out interesting and the message is timely, Bishop Cedric preached a highly inspiring message on the esoteric dimension of man. He is a fine and experienced teacher who takes the crowd along when he speaks. First time visitors are welcomed and told to come forward to the front of the podium, Yemi and his family go forward standing close to the marble platform as Bishop Cedric and Julius say hello and shake hands with the first timers. As Thomas Cedric beheld the Benjamins he looked at the baby and the Voice said 'this is the man Three, the Divine has chosen' all of a sudden he realised this was the baby the bottle of oil he received in Cirsqua

was for, he recollects the angel in Cirsqua told him this day would come.

He makes arrangements for the Benjamins to see him when the service is over.

The Benjamin's have an interesting and lengthy discussion with Bishop Cedric after the church service about their family, life's experience and their baby. The Bishop counsels them and they agree on a naming ceremony for the baby which they fix six days away . As the Benjamins walk away the Bishop gave thanks to the Divine for the fulfilment of prophecy and for his role in the plan.

Everything is in order, following the divine blueprint just as i was told in Cirsqua the Bishop thinks to himself.

As the Benjamins drive home the angels Sirael and Aseyi glide protectively beside the car. Yemi and his wife spend the next five days planning the naming ceremony and celebration, as the custom is they invite a few friends and family members to celebrate with them. Bishop Cedric will be coming around to conduct the ceremony.

Meanwhile the dark realm have received information about the forthcoming naming ceremony and celebration, they have an intelligence network fuelled by wickedness and they have discovered who the baby Olaniyi is. At one of the midnight meetings of their human agents through the skill of astral projection they were illegally able to access sacred heavenly writings and pin point who this present day hero will be. Their plan is to summon all diabolical powers to take out Olaniyi at his prime before grows to discover what his assignment is . Their first attack is scheduled for the day of the naming ceremony, that assignment has been given to Belilia a powerful voodoo priest who resides at the middle belt area of Nigeria. He is dark skinned, tall, largely built, pot bellied, bald headed and has a thick moustache . He has dedicated his life to the service of the dark Lord since his youthful years, he is a master in alchemy and black magic which he studied with the 'masters' of Arabia who are deep in sorcery. At precisely six pm on the day of the baby boys naming Belilia enters his shrine which is within his residence at his back yard garden. Within his shrine he has effigies, a magical staff and all sorts of ornaments hanging around, he sits at his alter and

takes a newly made effigy of a baby representing the child of the Benjamin's and starts saying all sorts of incantations over it. He summons a curse which appears in the form of a black cloud and he commands it to harm the baby. The cloud moves off speedily to its commanded target at superior speed.

Meanwhile, the naming ceremony has begun at the Benjamin's residence. The weather is calm and the neighbourhood is peaceful.

The angels, the couple, friends and family have gathered together. There is music and dinning, after saying prayers and singing a few hymns Bishop Cedric holds the baby in his hands. The names the couple have chosen for their new baby is called out by the Bishop, friends and well wishers. As everyone claps and rejoice the Bishop brings out the little bottle of oil given to him at Cirsqua, he pours half of the bottle on the baby's head, as the oil touched the baby's head the Spirit of the Lord came upon him. It was at that hour the black cloud entered the house but it bounced back as soon as it touched the baby's body instead of entering his body to harm it as it was instructed. The cloud flew back to its sender at the force of impact, twenty metres away from Belilia it divides into seven parts and each part turns into balls of fire as it got closer to Belilia's shrine. They hit the shrine and consume it. Belilia ends up being badly hurt, and his shrine, effigys and ornaments are consumed.

It will take a while for Belilia to erect a new shrine, heal from his wounds and gather together some of the rare objects and fetishes he had in his shrine. This has not been a good operation.

Times goes by and Olaniyi grows into a balanced and fine young boy as he passing through the normal process all children go through from Pre - kindergarten to kindergarten and primary school. He likes cartoons, animation and science - fiction movies. The Benjamin's are a happy family and Olaniyi has a happy childhood filled with memorable moments with his peers, joyful family times with his parents and some unique experience. One of such moments was when he was ten years old, he was on holidays which he spent with his cousins Faith and Nathan the children of his uncle Tunde his mothers older brother and his wife Veronica. Their family went to the Takwa Bay beach along with Olaniyi's parents where they had a barbecue and picnic outing on a nice and sunny Saturday . As

Olaniyi was playing a game of hide and seek with his cousins he ran to one of the nearby sheds on the beach to hide, this parents and cousins parents were distance away deep in discussion. Sweating and panting profusely he takes cover under the shed with the belief that his cousins won't find him there. After about two minutes he notices a cute girl of about his age standing near the shed to his right. She has the most radiant smile, he can perceive there is something different about her but he could not place a finger on exactly what it is. As the girl walks into the shed to sit down beside Olaniyi she seems to grown taller with each step she takes. Hello, who are you? He asks her and she replies that she is the Holy Ghost. Is the Holy Ghost a girl he asks curiously. 'No i am of no gender i am Spirit but i have appeared to you in the form of a girl your age so that i can relate with you in a way you will understand and so that i can get your attention without you being sceptical, besides the Body of Christ is referred to as a bride which is female. I also know it is from right about this age that boys start taking an interest in girls, though in a strange kind of way '. They both burst into laughter. I have a gift for you she says and she opens her hand, on the palm of her hand appears a ball of light. It seems to be breathing. It is alive! Wow, what is inside that light Olaniyi asks . Immediately she speaks to the ball of light to reduce its intensity and all the light surrounding it reduces to the point that Olaniyi can see what is within it. Within it is a transparent ball and within the glass like transparent ball is the star of David, two equilateral triangles with one pointing upwards and the other pointing downwards. The Holy Ghost proceeds to tell Olaniyi what the star of David represents. 'The triangle pointing downwards represents the Trinity reaching down to man .One edge of the triangle represents the Father, the other edge represents the Son while the third edge represents the Holy Ghost. The triangle pointing upwards represents God taking man to the top. Today God has reached down to you and as this Day star enters your heart you will enjoy upward mobility in your life by the power of God against all odds. It is a covenant of God with you'. As soon as she finished saying that, light appeared all over the ball and moved into Olaniyi's heart causing a warm sensation within his body. He feels an instant joy and confidence. She smiles at him and two men appear beside

her. The three of them disappear at the same time. Shortly after they disappeared his cousins Nathan and Faith find him alone at the shed. Faith and Nathan are always happy to have Olaniyi around during holidays. They are usually up to all sorts of cheeky antics and their parents take them out more whenever their cousin is spending time with them. His uncle Tunde and his wife Veronica are rich, they own a beautiful ranch outside the city of Lagos that has wild life, they breed horses and have a lovely holiday house on it. Olaniyi, Faith and Nathan love going to the ranch because there is a lot of space there for them to ride their bicycles and run around with the family pet, a golden retriever called Bruno. They also take walks into the nearby forest where they build tree houses.

The Benjamin's have maintained a good relationship with Bishop Cedric, their community and the church over the years. Olaniyi is growing in stature, in wisdom and in favour with the divine Three, and men.

He attends Baptist boys' high school, he is in the boarding school in Ogun state Nigeria. Alex Uti is one of his best friends in school . Always happy to come home during mid-term breaks and holidays, he has excelled well in his studies and his spiritual life under the superior tutelage of Bishop Cedric and Julius who has a lot of fondness for him . Julius still serves at the Miracle church, he is now married and Olaniyi has an avuncular relationship with Julius' children . The angels have carefully and protectively watched over Olaniyi through the years but he has never encountered them. He never shared his experience at the Tarkwa Bay beach with anyone.

Twenty five years after his birth and with a first class political science degree from one of Nigeria's prestigious university he has earned a scholarship to Yale university for post graduate studies. It will be his first time outside the shores of his country and he looks forward to this new experience. His parents are also ecstatic about his progress and what the future holds for him. They keep him constantly in their prayers.

One bright and sunny afternoon he is at a beautiful restaurant near the waterside at the Lagos island enjoying a three course meal with Amina Hassan who is perhaps his closest friend, it is their way of celebrating his progress and their friendship. They have known each

other most of their youthful lives and have taken a liking to each other from their teenage years, they share similar views on a lot of issues and share some similar hobbies. She is always the first friend to visit him whenever he is home from the boarding school during their secondary school days and he likes her because she is beautiful and because she is his friend. Amina is Marys daughter the former receptionist with the miracle church, Mary got married about a year after she met Yemi Benjamin to a gentle man from the northern part of Nigeria who is a doctor. Amina is their first child, she is about two years younger than Olaniyi.

As they enjoy their meal and discuss on a range of interesting issues Olaniyi stops talking and looks deeply into Amina's eyes, she stops talking. There is a two minutes silence. What is the matter? Amina asks breaking the silence. Most times she can read him like a book and knows when he wants to communicate something important to her.

Olaniyi reaches deep into the left inner pocket of his bag and brings out a well wrapped little box which he hands to Amina. Amina receives it with delight and surprise and unwraps it as she smiles. As soon as she unwraps the first layer she realises there are other layers covering the package. You are cheeky! She says. Olaniyi laughs and encourages her to continue unwrapping the little package. She unwraps it after going through five layers of wrapping paper. It is a little black box concealing a very expensive engagement ring. She opens the box and sees the exquisite engagement ring glittering under the light from the dinner table, she smiles with delight.

'It must have cost you a lot of money, it is so beautiful'

'Even if i have to spend all my little lifes savings to honour you by marrying you i will gladly do it. You are worth it, you deserve to have that ring and much more'

Olaniyi proposes and Amina accepts to marry him. With tears of joy cascading down her cheeks she says very calmly, i thought you would never ask, it is what i have always wanted and i have waited patiently for this day.

Olaniyi smiles, he places his right hand on her right hand, he leans cross the table and gives her a kiss. It is their first kiss, a special moment for them, almost magical. They agree to an engagement

ceremony before Olaniyi travels to the States for his postgraduate studies and they plan to get married when he is back. The couple hold hands, walk out of the restaurant and head for a nearby beach to enjoy the sunshine and the view.

Later that night Belilia the voodoo priest goes for consultation and help at the coven of three women popularly called the three red witches among those in the dark realm for what he considers a final attempt to destroy Olaniyi . He has been warned by the three principalities Horns, Nephilim and Apollyon at a mid night meeting of wickedness what his fate would be if he failed at this assignment. The three red witches serve horns and are second only to horns himself in spiritual hierarchy among human agents . They have risen phenomenally in the dark realm through sacrifice and dedication. They were young women of twenty eight, twenty nine and thirty years old each when they were recruited into the services of the dark realm. At different times in each of their lives they have sacrificed their first born children and their husbands as oblation to Horns.

The three red witches are the ones ungodly people searching for power, prestige and political affluence consult. The dark Lord, that fallen angel previously called Lucifer is the giver of delegated power to Horns while Horns delegates power to the three red witches. The dark Lord also called satan delegates power to the three principalities who are like his streams of outreach for Africa, the three principalities in turn give delegated power to different agents under each of their 'streams'. It is an intelligent and well organised satanic network. The three witches are the most powerful human representative the dark realm have.

Belilia walks deep into a thick forest at midnight with some charms and a torch light, it is as silent as a grave yard with only occasional sounds from owls and the hiss of snakes. Some bats fly across his head as he walks to the direction he has been instructed to get to. The glowing eyes of owls can be seen from many trees around him. He comes to an appointed rock in the forest, stands before it and says some incantations. The mysterious rock splits open and he enters it, within the rock is the palace and throne of the three red witches. As Belilia enters the palace, three governors from three

states in Nigeria and a President from one of the African countries are just stepping out of the palace back into the real world.

He steps before the three thrones of the three red witches, the carpet on the floor of their palace is red and the garments the witches have on is red. Belilia lays prostrate on the floor in honour of the witches who already know his reason for seeking their help. Three metres to their left is a cauldron boiling with red blood which was offered to them by different politicians and African leaders from various states and countries in exchange for success in their forthcoming elections.

A voice comes from one of the witches 'our humble servant you may speak'. 'I have come that i may be initiated into a deeper level of empowerment as you well know my lords. There is one who i seek to destroy, i have been assigned as a spiritual hit man to take out a young man called Olaniyi Benjamin in his prime . Hitherto i have failed in this assigned task and this is my last chance or else my life will not be redeemable'

'We already know your predicament humble servant Belilia, because you have bowed to us and given us your worship we will do our best to aid you. We will empower you so you can destroy your target and find favour with Horns our lord'.

Through his sweat Belilia is able to put up a smile as he lifts up his face that was bowed to the ground up to the three red witches.

The witch in the middle signals to Belilia to come forward, he ascends the steps that lead up to the throne of the witches and each of them hand him a staff, each staff is of different lengths. The shorter staff is the least powerful, the longer staff is the more powerful staff while the longest staff is the most powerful staff. The witches tell Belilia that with these staff he could summon servant demons of Horns to do his bidding and destroy people at will. The longest staff brings instant death to any living target it is pointed at by drying up the blood of the individual instantly.

'If these do not work for you there is nothing else we can do for you, that means you will have to face your fate. We have infused our power and authority into these staff, what we will do for you personally is what these staff can do for you. We wonder why this young man has been such a challenge to you'. The red witch on the

extreme right brings out a crystal ball to check out Olaniyi's spiritual stand. 'Belilia ! You need to be careful with this one. He is one of those called sons of the covenant, he is one of those blood bought ones. Work with a strategy and use the power of numbers against him. For i see fire and angels of protection around him'. Belilia bows in gratitude and departs from the presence of the red witches with the three staff.

As he departs the witches watch him leave knowing he may not succeed in this assignment, the dark world operates by deception and most of their human agents are not told that there are some people they cannot destroy or touch. Many had to find out the hard way, for some it was too late. The dark Lord also called Satan and his three 'generals' Horns, Nephilim and Apollyon don't care about the well being of their human agents or points of contact when they fail at an assignment. They do not suffer fools lightly.

Over the past few days Olaniyi feels some strange presence around him. He has been seeing what looks like a dark manly image, a silhouette following him around but he has not been confident enough to tell anyone about it. He does not want to sound crazy. He saw that tall silhouette again on his way from the library today, but each time he tries to get close the image vanishes. Whenever he feels the presence behind him he looks back but does not see anyone. Eventually he decides to confide in his dad who is now over fifity years old. Yemi smiles as his son narrates his experience. He asks to be excused for a brief moment and talks to his wife about their sons observations. 'I thinks it is about time we tell him, he is old enough and he is mature enough to understand the responsibility ahead of him.'

Yemi and Elizabeth have their son take a seat at the dinning table with them, they tell him of their experience with the angels and the prophecy concerning his birth while Elizabeth was pregnant.

'Apparently you have been chosen to deliver Nigeria from its fast decline to the precipice. I am convinced the image that you have been seeing lately is one of your guardian angels Aseyi and Sirael. They were the ones who appeared to your mum and i when you were still in the womb' Yemi said.

So why didn't you tell me this all this while ? he asked his parents. His mum replies, it is because we want you to be of a mature age before sharing certain things with you . There are certain things we believe you couldn't handle until now. We didn't want anything disturbing your normal childhood and growth. Bishop Thomas Cedric also advised us to keep this information to ourselves until you are grown. He understands your purpose, only the Divine could have connected him to us. He has been a blessing in so many ways.

Yemi and Elizabeth eventually tell their son Bishop Thomas' heavenly experience as they understand it. They do their best possible to help Olaniyi come to terms with all the information he has to take in. His mum gets him a mug of hot beverage and fixes him a delicious dinner.

After a warm shower he plays a Byron Cage compact disc while reclining on his bed, there are so many contemporary musicians but he still prefers the oldies. No wonder i have had this burden for Nigeria and the oppression going on on African soil, it must have been a clue to what i have been called to solve. No wonder i found myself opting for political science among all the courses i had the choice of studying at the University. No wonder i was digging into the history and pedigree of Africa today at the library. That explains the reason i am fascinated by success stories especially out of Africa. It is all so interesting but how do i solve Nigeria's problems or Africa's problems? I am just one man.

As he pondered on these thoughts an audible voice said to him 'you do not understand the power of one'

He looks around in surprise wondering where the voice came from, to his right is the silhouette figure that has been following him recently. Who are you ? Olaniyi asks.

Immediately the image becomes clear and appears in his true image. I am Aseyi, i have been one of your guardian angels from your birth. Shortly after Sirael appears and Aseyi introduces him, they both chorus 'we are the ones who appeared to your parents before your birth'.

Sirael tells him the Divines humble servant Bishop Thomas Cedric will be departing from the earth soon, he has been obedient to the heavenly instruction and he has a blessing that is for you with him.

You were given the gift of the spirit of the Lord during your naming as a baby that is why you have excelled well. The time has come for you to receive the second part of the gift which is essential to your assignment. We will be back shortly to give you the last key.

Both angels vanish at the same time.

Awe struck by this experience, he heads to his parents to tell them of his encounter.

The following morning he drives down to Bishop Thomas Cedrics house which is two streets away from the church, Miracle House. The Bishops wife opens the door, welcomes him warmly, and informs her husband Olaniyi is around . Thomas Cedric walks to the sitting room not looking surprised. Olaniyi narrates his encounter from yesterday, after listening patiently to Olaniyi the Bishop tells him of his heavenly experience in Cirsqua, his naming service and about the anointed ointment he was given at Cirsqua.

I believe the second part of the gift is the remaining half of the ointment i have with me. I knew this day would come because i was told it would by the angel of Cirsqua. Thomas Cedric goes indoors and comes back three minutes later with the little bottle of ointment.

They go to a vacant room where the Bishop says some prayers for Olaniyi who is on his knees. As soon as he pours the remaining ointment on Olaniyi's head a supernatural wind blows within the room, though the rooms windows are closed. After about two minutes the wind stops blowing and the divine formula for Nigerias' political and economic salvation is supernaturally imparted into Olaniyi's soul. He feels a sensation in his brain and he feels revived and refreshed.

He drives back home and realises he has become more skilful in wisdom, more cunning in knowledge and has a better grasp of lifes issues. His mind has been upgraded, and his consciousness perfected. Right from that moment onwards there is a touch of excellence to everything he does.

As Olaniyi and Amina prepare for their engagement ceremony he dedicates his spare time to studying, meditating and serving his community through the outreach arm of his local church. He never discussed his angelic experience and discoveries with Amina.

About two months after the angels appeared to Olaniyi they appear again as promised.

It is ten pm, Olaniyi is watching a medieval movie when a bright light appears to his right hand side. The light shines from the ceiling down to the floor, out of the light steps Sirael and Aseyi the ministering spirits. Instantly his dvd player paused automatically.

'We are sorry to interrupt your entertainment. We are here to bring you the last and necessary key for your assignment' they say this at the same time. Why me? He asks the angels. Sirael replies, there are many young men out there who will gladly accept this assignment. Men who are more qualified by human standards because they are from noble homes.

Aseyi replies, 'God uses the foolish things of this world to confound the wise. The base things of this world to confound the mighty. You are from a good and modest home and you have been chosen by divine selection'.

So what is the last key, what do i have to know?

'That is a good question, questions are the answers.

You have already been exposed to the word of God. You and your parents have been guided by heaven to accept the faith and understand Gods word, you have been privileged to learn the Word and spiritual mysteries under one of Gods choicest servants. You are one of those washed in the royal blood of the lamb.

You have excelled and done well as the heavenly pattern for your life shows you should . You have twice been anointed with special oil from heaven but we want to give you the revelation of Makaira.

For your dominion you have to know how to apply the Word of God as a sharp sword that cuts through any issue of life. This is what the revelation of Makaira is'

Olaniyi asks, what is a makaira? Sirael takes some time to tell Olaniyi a bit about Roman history and how the makaira is a type of sword discovered by the Romans at a time their longer and heavier swords where not efficient enough in times of battle. It is light, sharp and cuts neatly and deeply. The Romans found it efficient. The Word of God works like that. The beauty of Gods Word is that it covers all areas of life and when it is used as a makaira, when its used with skill it will deliver results to you in all areas of life.

Gods mouth and your mouth make it a two edged sword. When there is a synchrony and harmony between what God says in His Word and what you are saying in all situations then the double edged sword will work. With it you will overcome all the emissaries from the dark realm and walk the nation and ultimately the continent out of darkness. With this revelation and its appropriate use you will be spiritually empowered and politically relevant.

You will rise to great heights in life and be a role model to many but be warned that you will face numerous trials in your life's journey. But be of good cheer because trials are the raw materials for triumph

We have been instructed to teach you how to gain mastery, to show you how to unlock the mysteries of your soul, to teach you how to freeze your thoughts and manifest them in the physical realm. You must have a Spartan self discipline. As we teach you this sacred ways you must commit five hours every day for two months and you must not tell anyone about it. The moment you do we will stop the teachings.

Olaniyi promises to keep it a secret and abide by the laid down rules.

The angels promise to come back the same time tomorrow, then they disappear.

Over the next two months Olaniyi commits himself to the tutelage of the angels every night for five hours.

On a date that is chosen by both families Amina and Olaniyi eventually have their introduction ceremony. There is lots to eat and fun fare. It turns out to be a combination of an engagement ceremony between the couple and an introduction ceremony between their families. The custom is for the families to know each officially and get acquainted with one another through ceremony. It took place at a community hall with family, a few church members, friends and of course the angels who are unseen visitors.

There is a guest artist who is serenading the guests with entertaining music, there is also an exchange of gifts between the future bride and grooms family. As all this is going on the heavens are watching. There is an opening in the heavenly realms from where Sag and other inhabitants of Cirsqua watch.

# Chapter 3

# LIGHT AND DARKNESS

'I will attack him from the dream realm . While he is asleep, he will be as good as lifeless and those agents from heaven will not be in his dream to protect him. If i take him out in the dream realm he will be dead in the physical realm'

Belilia takes the shortest staff in his hands chanting and beseeching five fierce and destructive spirits from the dark realm to help him. They appear out of the staff in the form of dogs. One looks like a boxer, another a Doberman pincher, a bull mastiff, an afghan hound and a mutated bull dog. With the staff he sends off the hounds of hell into Olaniyi s dream to destroy him.

Suddenly, Olaniyi begins to dream. At first the dream starts off positive and beautiful, he is having a picnic with Amina under a clear blue sunny sky in a beautiful open lush green park. He and Amina touch each other tenderly and there is affection in their eyes, she is wearing the engagement ring he gave her and a smile . Suddenly dramatic changes start taking place. The sun turns into the moon and the clear blue sky into the darkness of night, the lush green park changes into a grave yard and a rose he gave her in this dream withers before his eyes. As Olaniyi tries to figure out what's going on he realises he is all alone in a cold and empty grave yard full of tomb stones. Amina is not there anymore.

The hounds summoned by Belilia appear. They reveal their fangs to threaten, they bark aggressively chasing Olaniyi. In fear he runs for his life. It is dark, it's the bit of light glowing from the moon he depends on to navigate his way. He falls over so many times and sustains an injury to his right leg but he gets back up, the dogs seem to catch up on him as their growl echo through the night.

Sweating and panting with no where to go and no where to hide he thinks fast on his feet, his life depends on it. "The word of God is a double edged sword that cuts to the dividing asunder of soul and spirit. It will give us victory in any situation of life". These were words Julius shared from the Book at one of the youth meetings at the Miracle House.

He remembers the art of 'mental freezing' that his guardian angels taught him. One of the dogs the Doberman pincher is fast gaining in on him and drooling at the same time. As quickly as he can he visualises the Word of God and 'freezes' it in his soul, it immediately materialises in his hand as a Bible which instantly turns into a double edged sword, a makaira.

He turns around and the Doberman leaps at him, he strikes the Doberman and chops its head off. The dog lies lifeless on the ground without any trace of blood, the other dogs catch up and give him a ferocious fight. With his clothes torn, dust all around him and a few scars he successfully kills three of the dogs. They all lie lifeless without any blood coming out of their bruises and body. As the last dog, the mutated looking bull dog with its fangs sticking out charges at him he employs the skill of mental freezing again. He remembers the Divines word says "your arrows are sharp in the heart of the kings enemies" as he freezes that imagination in his mind the makaira turns into a Bible and immediately the Bible turns into five arrows which move with superior speed piercing the face of the mutated looking bull dog. The dog slumps, its dead. All five dogs vanish into thin air.

Olaniyi suddenly wakes up panting and sweating. He realises it is a dream and is grateful to the Divine it is over. But he understands it is more than a mere dream.

A week later Bishop Thomas Cedric passes on into glory. His family, friends and the church respect his wish to be buried in Nigeria, a

nation he took as his home and fell deeply in love with. Right from the moment he stepped on the shores of Nigeria as a younger man he has always felt a kindred spirit with Nigerians. He took to the Nigerian culture and he enjoyed African dishes, he also liked Nigerian traditional festivals and dance. He understood his calling is in Nigeria and knew he has some important role to play in Nigeria which would be unveiled as time goes by. He is a man blessed in all things.

He has became part of the cloud of witnesses cheering on Olaniyi Benjamin and other sons of the covenant from the grand stands of heaven.

His only child, a son who is a lawyer in New York is in Nigeria for his fathers' burial.

Thomas Cedric is buried at his private residence two streets away from the miracle house church on a Saturday morning. The majority of his congregation, friends, colleagues and representatives from Christian organisations like the Pentecostal fellowship of Nigeria (PFN), and the Christian association of Nigeria (CAN) are at his burial to pay their last respects. It is a quiet and pleasant ceremony with an evening celebration for a life well spent.

After a series of meetings and deliberations with the agreement of the Miracle House Church members Julius is appointed as Bishop Thomas Cedric's successor.

Meanwhile at a different state about four hours drive from the city of Lagos Belilia has another shrine erected for him where he carries out wicked machinations and consults powers of darkness on the behalf of people of the local community who pay him to do so. This is the major way he makes a living.

He chooses another day to carry out his next strike on his primary targets life. It is towards the ending of the month when there is a full moon. On that day, at night he enters his shrine and remembers the three red witches advice to him.

'Use the power of numbers against him' Belilia remembers, he picks up the second staff and summons diabolic powers of the grave. Twenty spirits emerge from a cemetery in London and travel down to Nigeria at the speed of sound. At Belilia's instruction each of the twenty spirits vanish from his presence and appear in that territory where spiritual forces of wickedness have made their headquarters

called the second heaven. An additional twenty demon spirit of wickedness, servants of Apollyon join the diabolic powers of the grave. They are all ready in battle against the Lords anointed. Some of them have swords, bow and arrows, guns, magic wands and snakes and bows, the snakes serve as the arrows for the bow.

Belilia attempts to summon Olaniyi's spirit to the second heavens with the staff in his hand. It is not good timing. He is making this attempt at a time his target is involved in mid night prayers. A night vigil programme is on at the Miracle House church, Olaniyi and his parents are part of it. Belilia's attempt fails.

After pondering for awhile and realising he can't carry out his intentions in that atmosphere of prayer he decides to do it when Olaniyi is asleep. Belila summons an elemental spirit and commands the spirit to put Olaniyi to sleep, at this time the miracle house congregation is receiving a word of exhortation from Julius.

The elemental spirit appears outside the building and throws an invisible syringe injection into the building through the window and he vanishes. The syringe moves toward its target, it hits Olaniyi and injects spiritual liquid into his body. Moments later he is too tired to concentrate on the teaching and prayers, he falls fast asleep.

Realising he has succeeded in putting Olaniyi to sleep, Belila attempts to summon his spirit to the second heavens again. This time he succeeds, Olaniyi's spirit leaves his body, ascends heaven ward, moves rapidly through the clouds and the night sky and finds himself in a beautiful realm that is full of negative energy and unfriendly looking spirit beings of all sorts. In this realm called the second heaven, evil schemes of all sorts have taken place here from the time the first man God created called Adam lost his authority to satan the deceiver. It could be that Satan resides at one of the planets of the solar system

Twenty five metres away from Olaniyi is a huge golden coloured form with the facade of a masculine man sitting on a throne. To the right of his throne is a pit that seems to be alive with a powerful suction like a whirl pool. It is Apollyon himself the chief of demons and archenemy of Africa, loyal general of the diablos called Satan. The spirit of backwardness and the bottomless pit.

In between the space between Apollyon and Olaniyi appear the twenty forces from the grave and the twenty spiritual forces of wickedness. More confident of who he is and armed with testimonies of previous victories Olaniyi braces himself for battle. As he visualises it and decrees it a double edged sword appears in his right hand, the blade of the sword rotates on its handle with great speed as it glows. Another appears in his left hand. The powers of darkness have never seen anything like it. He races toward the mob of dark powers with a shout of assurance of victory. Five of the spirit forces bring out their bows and pull out their snakes from their quiver. The snakes are put to their bow and instantly become hardened like arrows, with their mouths wide opened and their fangs serving as the pointed tip, they are shot at Olaniyi. Rightly applying the swords as he runs towards the mob of wickedness he uses the swords to deflect and cut the snakes shot at him. With the backing of prayer from the saints in miracle house who have perceived something is not right, his strength is renewed during times he seems weak to the surprise of the hosts of darkness. Dark principalities surround the spot where the battle is going on, watching the fight as if it is from the stands of an emperors coliseum. They have never seen nor could they comprehend a human spirit fight with such skill and gusto.

The battle is ferocious, dramatic and intense as it shakes the realm of the second heaven. As Olaniyi's strength begins to wane the hosts of darkness begin to cheat sending in more evil powers into the battle after Olaniyi defeated the forty, he calls for the blood of Jesus which instantly forms a circle of blood around him. The first ten evil spirits that are foolish enough to get close are badly electrocuted. Perceiving he would soon be transported away from this realm he throws the rotating double edged sword at the principality on the throne called Apollyon. Apollyon dodges, the sword narrowly misses Apollyon but cuts him leaving a scar on his neck . He throws the second sword at the image of Africa near his throne and the image is shattered breaking Apollyon's hold and spell on the continent of Africa.

Instantly Olaniyi Benjamin's spirit is transported back into his mortal body. He opens his eyes in the company of the members of the church he attends, they surround him. Many of them got a bit worried for

him and began prayers on his behalf. Are you alright? Amina asks him as she hugs him fondly. 'You scared us.'

Olaniyi Benjamin's fame spreads throughout the heavenly and earthly realm of the kingdom of darkness! He is grateful to the Divine he came out of that alive, from that moment on his life became one of constant gratitude.

Enterprising and full of wisdom for witty invention he registers and starts a career and entrepreneurial center run by him, Amina and Alex Uti. It has rapidly and steadily become a household name and its profitable business as the young and old come by the walk in center for consultations in business and career counselling.

The evil realm is not happy. They run to and fro to hinder Nigerias progress by all means, they perceive the light and can almost see it ahead.

Time is running out for Belila, perpetually disturbed and silently tormented he has never found himself in such a difficult spot since he has been working for the dark realm.

Full of anger and disappointment by his previous failures and with the desperation that his time is almost up Belilia makes his final attempt at Olaniyi's life. He grabs the last staff which is the most potent of the charms the three red witches have ever given him. It is the longest and most powerful of the staffs. He arms himself with charms and chants incantations for his own protection before going after his target, his aim is to bring instant death to the Divine's chosen. But unknown to him the Divine laugh at him from heaven which has sealed his doom. It is a five hour journey from his city to Lagos, with the help of a guide spirit he is able to trace Olaniyi's location. While driving home from one of his entrepreneurial presentations in the evening he realises he has a flat tire which he is not aware is caused by Belilia's guide spirit. As he pulls over to have his tire changed he sees Belilia standing before him, he can tell Belila is up to no good.

As Belilia points his staff at Olaniyi, instead of Olaniyi's blood drying up and bringing instant death the staff suddenly and surprisingly turns hot without being consumed, this is inexplainable because the staff is made of wood. Belilia's hand is scarred and he drops the staff which explodes immediately it dropped on the floor. He becomes the

macabre of spectacle as the charms on his body catch fire and he is badly hurt to the surprise of the public.

After being defeated this time around the vengeance of the dark realm comes upon Belilia, he runs off into the thick forest as a mad man never to be seen again by any mortal eye.

The three red witches are disappointed they have lost their most faithful worshipper and friend and decide to personally wipe out Olaniyi from the face of the earth. He is becoming too much of a threat to the kingdom of darkness. If things continue with him the way it is going, he will fulfil his destiny which they cannot afford to happen. The dark realm cannot afford to lose their grip over Nigeria.

But slowly some positive developments begin to take place in Nigeria after Olaniyi's battle and destruction of Apollyon's image of Africa in the second heavens. The naira, Nigeria's currency begins to gain value at the stock market. The incumbent president of Nigeria begins to receive more invites to world leaders meetings and more African countries are given the chance to take their place at global summits.

# Chapter 4

# THE FIGHT FOR DESTINY

A new semester is about to start at Yale, Olaniyi has his luggage ready. There is music by Fred Hammond playing in the background of his room, he is taking a look at his passport and ticket when his mum walks into his room. As soon as she walks in he reduces the volume of the music player on the desk in his room with its remove control. He knows his mother must have some motherly advise for him. She helps him adjust his tie like she usually does for her husband when he is getting ready for work most mornings.

'Hello son', hello mother he replies. She gives him advice just like her son suspects, she advices her son to stay focused, prayerful, humble and to put business before pleasure.

'Remember your engaged to a lovely, intelligent and friendly lady and you are a fine young man. Keep all those girls you will meet at a distance. Some of them will be up to no good. As lovely as we ladies can be we can be a distraction to men who have a dream'.

'Mum you worry too much i know what is right, you and dad have done a good job bringing me up and i intend to keep to the traditions of the family'. I am happy to hear that his dad responds as he walks into the room at that moment, he had been at the door listening quietly to his wife and sons discussion.

He walks up to his son and gives him a hug. He whispers in his son ears you have made us proud but i know you will still make us more proud.

The three of them hold hands as Yemi leads his family in prayer for his sons success and well being. Elizabeth sheds some tears, she has never had her son leave home since she had him. She finds it hard to imagine he will be away for two years. Time seems to have gone by so quick, he is all grown up now.

Mr and Mrs Benjamin are so proud of their son. He has grown into a fine young man. Elizabeth looks at her son closely and it dawns on her that he looks like one of the guardian angels who appeared to her and her husband when she still had him in her womb . He looks like Aseyi. She tells her son what she thinks and he replies her, that of the two angels, he is closer to Aseyi.

Elisabeth proclaims, I have made supper, let us eat . We don't want you missing your flight and i want you to eat the food i have prepared before you leave.

Amina walks in as they are having supper. She is around to see her fiancé off at the airport. She is so comfortable with the family and Mr and Mrs Benjamin have taken a liking her just like their own biological child. She walks into the kitchen, serves herself some food and joins them at the table.

Yemi drives Amina and his family to the Murtala Muhammed International airport . There, they make sure Olaniyi's suitcases and travelling bag is checked in. With two hours to go before he boards the flight they all have a walk round the airport. Yemi and Amina pop into the shops, cafes and book stores within the airport to do some buying and sightseeing, while Olaniyi's parents are back to their seats at the waiting space .

Alone as they have a cup of coffee at a cafe, Amina presents her fiancé with a gift. He opens the little black box and within it is a chain and circular pendant made of pure gold. The pendant has the inscription 'love of my life' on it. As Olaniyi tries to express his gratitude she puts her index finger over his lips, she plants a kiss on his lips, takes the gift out of its box and wears it on her fiancés neck. She tells him to wear it always and to always think of her. They smile at each other.

An announcement comes up that the next plane leaving for the States has started boarding. Realising that it is his flight the couple hold hands and leave for the departure section where his parents are waiting. He gives each person a hug and leaves with other travellers taking the same flight with him. Before he is out of his parents and fiancées sight he turns around and blows them a kiss. He boards the plane and takes his seat.

It is a night flight, the journey is twelve hours. He thinks about his family and the task ahead . Time goes by quick, before i know it i will be back in Nigeria with my family and the woman i love he thinks to himself. I feel blessed to have a lady like than he wispers as he takes another look at the gift on his neck. He knows Amina and Alex Uti are capable and good friends who will take care of the Career and Entrepreneur center, the business they started together. He has his meal and snacks.

After watching a series of Charlie Chaplin performances showing on the screen before him he falls fast asleep.

His flight lands at the Airport, where he proceeds to Tweed – Newhaven airport which is approximately four miles from the Yale campus. Yale staff were at the airport waiting at a designated section to pick up and welcome their foreign students. They have two placards to welcome their foreign students. As soon as the batch of guests and students expected had showed up they were driven in space buses to the various residential quarters where they will be staying.

At Yale University he is at the graduate school of Arts and Sciences. The campus is beautiful and there is a tour guide taking first timers, international students and visitors around the campus. The campus has lots of historic buildings and a wide array of centers, libraries, museums and administrative support offices. It is just as he saw it on the Yale website when he and Amina checked it online.

Touring the hundreds of acres in the heart of new Haven is such a delight for the tourists and new students as they visit Harkness memorial tower, Branford court, Daniel L. Malone engineering center, and the Sterling memorial library amongst other sites on open mini vehicles as they move in groups.

The tour guide proceeds to tell them about the history of the school as they all gather under the shade of a large oak tree. "The history of the Yale can be traced back to the nineteen forties when colonial clergy men led an effort to establish a college in New haven to preserve the tradition of European liberal education in the New world.

The vision was fulfilled in seventeen hundred and one when the carter was granted for a school where the youth may be instructed in the arts and sciences and through the blessing of almighty God may be fitted for public employment both in church and civil state. The school was renamed Yale college in gratitude to the Welsh merchant Elihu Yale, who has donated the proceeds from the sale of nine bales of goods together with four hundred and seventeen books and a portrait of King George the first".

The group clap in appreciation for that brief insight into Yale's history.

It is an interesting history to listen to. And the group has an opportunity to ask questions about Yale College.

After the tour the group got acquainted with one another before they part ways. A gentleman called Hakeem is in the group, he and Olaniyi get along and start a friendship. They share similar concerns, views and beliefs about their country and their faith. They are both Nigerians, they are both taking post graduate courses, they are of the same age. They take a walk across the lawn to get some ice cream. Within a short period of time they both settle into the order of things in their new environment and commit themselves to their academic pursuit. Olaniyi excels rapidly and becomes well known on campus and with his lecturers who find his brilliance baffling. He is taking political science while Hakeem is specialising in people development.

His friendship with Hakeem grows. Hakeem used to be of the Islamic faith, he turned Christian a few years ago before coming to Yale College, he is from a muslim background. They study together at night from time to time, 'burning the mid-night candle'.

Through phone calls, emails and free online chat services and virtual user utility websites Olaniyi keeps in touch with Amina, friends and family back home.

Meanwhile in the heavenlies far above the earth, in that realm where principalities, powers, diabolical rulers of this world and spiritual forces of wickedness have made their home and headquarters, Apollyon is wrath with Olaniyi and the disgrace he caused him in the sight of lower ranking demons. Full of vindictiveness he thinks, if he could have disgraced me in my world, i will disgrace him in his world. He decides to take on the body of a man so that he can function on the earth, for spirits can't function legitimately on earth without a body. He journeys downwards gliding slowly and gently onto the earth as a spot of light.

Star gazers and astrologists studying the skies at that moment think and conclude that it is an unidentified flying object (UFO) they see, by the next morning their observation is on the headline news and on the internet. It became the most watched video on you tube.

At Santa Monica Boulevard in Los Angeles is the large building complex of the Bio-life technologies . They have a well equipped high tech group of laboratories and a secret and select group of scientists dressed in blue and white overalls most of the time. For the past ten years they have been openly pursuing human cloning.

They have achieved a breakthrough. For the first time in human history two identical human bodies of a grown man of about thirty years old have successfully been cloned. The cloned body is the body of a brave, physically fit and well built military officer who fell in battle two years previously on an assignment with a special team outside the shores of America. The scientists at work on this project realise the life force that keeps the human body alive called spirit cannot be produced by man. There is no life in these bodies and they have tried in vain to make the bodies live by special mechanisms. The best they can do is operate these human bodies like robots. It is not what they want.

Frustrated by their inability to make the bodies function like normal men they decide to destroy the bodies and end the secret project. At night they turn the fire in the incinerator on and an hour later the first body is thrown in.

That same night Apollyon appears on earth, landing on an open field in Los Angeles. Perceiving there are vacant bodies to inhabit he appears at the Bio cell laboratory just before the last body is about

to be burned in the incinerator. Like a gush of wind he moves into the cloned body through its nostrils and the body comes to life. He opens his eyes and jumps off the platter to the astonishment of the scientists and laboratory technicians. Sensing they are in danger, a technician presses the alarm bell which alerts the security there is danger in the building. Apollyon takes a laboratory gloves, he puts it on and picks up a sharp knife on one of the shelves, he kills everyone with speed and violent rage. There is a splash of blood around the room.

Naked, he pulls off the overall on one of the scientists . He covers himself and leaps out through the window before security officials arrive. Security officers get there and find only dead bodies and a window wide open with wind blowing through it lifting the mini curtains. Apollyon skilfully leaps over the wall of the laboratory building and escapes without being seen by any of the security officials outside or surveillance cameras. The police are called in, they carry out an investigation that turns out very hard to solve. No finger print is seen and no DNA evidence is found. They cannot explain how the cloned body  came to life and killed the scientists without leaving any trail of evidence and seemed to vanish.

The police decide to keep the happening a top secret. The public never got to hear about it.

It is the cold of the night, with nothing on but the white overall from the Bio-life laboratories, Apollyon breaks into a well known clothes store, he steals a few clothes, shoes and socks to wear. The alarm goes off but before the police could come around he escapes running out of the store with super human speed. As he walks past human beings looking at them through the window of human eyes he is full of hate for these creatures who he sees as weak and inferior. He wonders why the Divine extended the hand of salvation to man who he sees as things and not those of us of the angelic family. He wispers to himself in bitterness 'such miserable creatures, they are so loved yet many of them don't know it. They are chosen yet they do not know the value of it. We will do our best to make sure they do not enjoy the price that has been paid for their redemption, we will do our best to make sure they never see the light and that as many of them as possible will end up in eternal damnation with

us'. It is mid-night but the major highway is still very busy. At the snap of his fingers three demon spirits appear causing a ghastly car accident on the high way, it leads to an unnecessary hold up and the loss of several lives. As this happens an evil grin of contentment is on Apollyon's face. He walks to a nearby motel where he intends to stay for the night.

He walks into the reception and as soon as the eyes of the motel staff come in contact with him they come under his spell and are hypnotised. One of them hands him the key to the best room of the motel with the permission to stay there as long as he wants. As he lies down on his bed he feels very limited in his human body because he feels tired, in his spirit form he doesn't get tired. I hope i won't have to stay in this realm for too long,by this time tomorrow i will have destroyed that worm called Olaniyi Benjamin from the face of this earth. This is what he ponders on till he falls asleep. He steps out of his motel room neatly dressed in a pair of black jeans, light brown ankle boots, a leather buckle belt, denim dark blue sleeve top, a knee length overall and a hat.

Outside his motel he snaps his fingers and within minutes a brand new Harley Davidson motor bike appears in front of him. It was stolen by elemental spirits from a Harley Davidson dealership as soon as Apollyon snapped his fingers, the spirits brought it .

He climbs on it and rides to Yale University. He knows that is where his target is. Later on, that same night Olaniyi walks to his residential quarters after hanging out with Hakeem and a few friends at one of the complex of learning. Suddenly a rush of wind blows in his direction, as soon as the winds stops blowing a black cat that that has a bad rear leg is before him limping off into a nearby corner. He whistles to the cat hoping he can have a look at its leg to see if he can be of some help, walking after the cat he turns into the direction the cat heads to. Right at the corner is Apollyon looking great on the Harley Davidson bike, his hat is slanted towards his face which shields his eyes. 'Oh i didn't know its owner is nearby, i was hoping i could be of some help. I take it your his owner' There is no reply from Apollyon who has his hands folded across his chest. Suddenly the limping black cat which seemed to lean against the rear wheel

of the motor bike vanished before Olaniyi's eyes. That is when he realised the cat is a bait and he knows something is not right.

As Apollyon slides his hat unto his head a bright light twinkles out of his eyes.

Olaniyi realises this is not an ordinary man.

A powerful wind is released from Apollyon's mouth which pushes Olaniyi forcefully to the floor. He gets up and tries to run away in the opposite direction, as he runs a short distance he stops all of a sudden because he sees Apollyon standing right in front of him. He realises there is no escaping from this one without a fight.

What do you want he asks. 'I am the one you had the audacity to disgrace in the second heaven, how dear you. Your country will not be free for our time has not come'

As Olaniyi tries to run away again Apollyon brings out a long chain spins it in a nut above his head like a rodeo rider and swings it towards Olaniyi. He catches him. With the chain twisted round his waist he pulls him towards himself. As soon as he is close enough Olaniyi gives him a punch in the face and struggles to set himself free. Apollyon responds with a punch and a serious fight starts between both men.

Taunting Olaniyi, 'i will kill you and i will skin your dad and your mum alive. Then i will defile your damsel'

Full of anger he replies 'you will do no such thing! He immediately picks up a piece of rock near him and throws it at Apollyons face hitting him with impact. But to his surprise he realises Apollyon is not bleeding and he understands why.

Both men wrestle each other to the ground, as they throw constant punches at each other.

Bleeding from the right side of his face Olaniyi seems to be losing the fight.

As the battle is on all of a sudden Olaniyi seems to glitter, tiny bits of gold dust are spread out all over his body. It is heavenly dust, a symbol that the Divines presence and favour is with him for the battle.

He remembers the Word he came across during a time of quiet meditation that says Gods Word is like a hammer, he remembers this as Apollyon throws punch after punch. Olaniyi's thought takes on

substance and a mighty hammer appears in his hand. He hits Apollyon on the chest with the hammer which throws him off his feet and he crashes into a nearby tree. Apollyon gets up racing towards Olaniyi who throws the hammer at him a second time which makes him fall backwards in pain, but he gets up again to Olaniyi's amazement and surprise. The hammer is on the floor before Apollyon. He tries to pick it up but to his surprise he finds it too heavy and cannot lift it, feeling embarrassed he tries to pick it up again while Olaniyi walks towards him steadily. Frustrated he could not pick up the hammer he kicks Olaniyi with his right leg which lifts him from the ground racing backwards as he glides through the air twenty metres towards the glass windows of an imposing complex. But before Olaniyi who is almost lifeless could hit the windows the angels Sirael and Aseyi appear just in time to catch him with Aseyi holding him on his right arm and Sirael holding him on his left arm. At their touch he feels refreshed and revived and they lift him back to where Apollyon is. Apollyon doesn't see the angels on Olaniyi's sides as Olaniyi floats in mid air towards Apollyon with his arms outstretched and his legs close together as the invisible angels hold him, his body is positioned like the cross.

Stairing at Olaniyi strangely and with a bit of fear he takes steps backwards as Olaniyi is gently placed opposite him. The angels disappear as Olaniyi picks up the hammer lying on the floor.

He smashes his Apollyon' s forehead with the hammer. Apollyon screams, he is in excruciating pain. He rams the huge hammer onto Apollyon's forehead a second time, with cracks on his forehead his life force the spirit within the body comes out as silver rays of light. As he slumps on the floor the rays of light shoot straight into the sky from his forehead leaving his body lifeless.

Olaniyi moves hastily to his residence leaving the body and the hammer on the floor. By the next morning police are all over the section where the fight took place. It has been barricaded from students and staff because of their investigations. The hammer is not any where to be found. It is only the body that went missing from the Bio-cell laboratories that is seen as it lies lifeless like a shell with an open crack on its forehead. The mystical hammer has vanished.

What happened remains a mystery to the police and the best investigators.

Back at the second heaven at a secret meeting between the Lord of darkness and his chief principalities Horns, Nephilim and Apollyon, Apollyon expresses his concern that they will lose their hold on Africa because of Three's chosen one.

The next assignment is given to Nephilim by the dark Lord at a round table meeting. The dark Lords face is never seen by his cohorts, he is tall and huge and always has a long hooded black robe on. His feet are not seen, when he moves the skirt of his robe sweeps the floor at its edges. Nephilim's assignment is to break Olaniyi's momentum and divert his life's purpose. The Lord of darkness tells Nephilim to corrupt his soul and give him a different vision. If his soul can be corrupted his vision can be diverted. For the best way to destroy a man with a vision is to give him another vision. Nephilim is instructed to make sure that temptation and desires that war against his soul comes upon him.

The three principalities bow before their Lord after which Nephilim moves speedily to plot and carry out the plan.

Meanwhile at the coven of the three red witches they feel disturbed, angered and full of vindictiveness.

Seeing through their crystal balls that the destiny of Nigeria is intertwined with the life of Olaniyi Benjamin and to revenge the death of Belila their most loyal worshipper and patron, the three red witches themselves personally try to take on Olaniyi Benjamin through the dream realm. Fuelled by wickedness and with the blessings of Horns they appear in his dream as he sleeps at night hoping to bring death to him as they have done to some others in the dream realm.

In his dream Olaniyi finds himself sitting on a large rock opposite a flowing river in a picturesque but rocky area beside a water fall. He is wearing nothing else except a pair of shorts. Suddenly a woman very pleasing to the eye emerges out of the flowing river, she is the most attractive woman Olaniyi has ever seen. As he is spell bound in admiration, the tall lady walks towards him seductively as water from the river drips off her body, she sits beside him on the rock and begins to caress his body. A second lady equally beautiful emerges

out of the river and walks to Olaniyi and she also starts caressing his body . He feels carried away.

A third lady walks out from the water fall, the previous women wink at her. She walks up to Olaniyi and joins the other ladies to caress him, that is when it suddenly occurs to him something is not right. He fights hard to resist their temptation. The more he struggles the more the ladies increased their caress. As one of the ladies tries to kiss him he pushes her away. Falling backwards towards the river her real image manifests, she is the first witch among the three red witches. In shock Olaniyi breaks loose from the hold of the other two ladies who suddenly appear in their true form.

He runs away seeking a place of refuge, the witches fly after him bringing out magic wands . Each of them shoot beams of light from their wands with the intention of crippling him but they keep missing their target. One of the witches casts a spell which manifests as a giant sized Iguana right in front of him. The witches keep releasing beams at Olaniyi but they keep missing their target as the Iguana makes attempts to devour its potential snack, it emits fire from its mouth. He remembers he is never alone and he hasn't been destroyed by enemies because of divine presence irrespective of the challenge. He calls to this Father, the Divine for assistance. A still small voice replies him telling him to put his angels to work! As he hopes and prays for angelic assistance in his heart a bright light shines in the sky. The light splits into two and moves speedily in Olaniyi's direction, it's the angels Sirael and Aseyi. Olaniyi remembers the scripture that says "suffer not the witch to live" . He instructs the angels not to spear the witches, the angels and the witches battle it out in the sky.

He visualises a makaira and a shield, because Gods Word is all these things they appear in his hand, the shield is on his left hand, it is golden coloured, it has faith written on it. In his right hand is a glowing makaira. As he imagines a thing it manifests. A helmet appears on his head with salvation boldly written on it, a breast plate appears on his chest with righteousness written on it, a huge belt appears over his waist with truth inscribed on it while battle shoes with peace beautifully inscribed on them appear on his feet.

As Olaniyi battles the beast before him on the ground the angels battle the witches before them in the air. It's a graphic scene.

The first witch falls from the sky dead. Olaniyi is also prevailing against the fire emitting Iguana by using sword and shield skillfully. The second and third witch fall dead from the sky simultaneously as he also defeats the reptile. He got close enough against all odds to pierce its heart, its head slumps to the ground. He wakes up from his sleep victorious and grateful for his victory.

In the physical realm the three witches died and news of their death spread in the dark realm and across certain African bigwigs and politicians. The occult groups know the witches death is not a natural one, they found out they were destroyed in the spiritual realm. Their death in Olaniyi's dream brought about their death in reality.

Changes start taking place in the leadership of African nations as mysterious deaths started befalling evil leaders and workers of iniquity who were keeping the various nations bound. Revolutions start breaking out in different department of African nations as nemesis starts catching up with certain political 'hawks'. Many of them have a link with the three red witches who have passed away.

Olaniyi courageously proceeds with his life and studies, he is making good progress.

Nephilim is ready to carry out his evil scheme. He has prepared human agents inspired and motivated by his deception. Two gorgeous ladies who Nephilim has filled with the spirit of sorcery and an intelligent but spiritually naive guy, an acquaintance at Yale will be used. Like marionettes he will control them to do his bidding from the heavenly realms. He starts with the man. His name is Guy Chambers. Guy Chambers is from an upper class aristocratic family in Britain.

Suddenly Guy Chambers feels very racist towards Olaniyi Benjamin and envious too because of the favour he enjoys and his academic brilliance. Guy Chambers is one from a group of friends Olaniyi and Hakeem have brainstorming sessions with on their courses, about politics, life as it should be, current affairs and third world countries, as they have been called for too long .

Lately Guy has been openly opposing all of Olaniyi's views during their study and brainstorming meetings, he has been very unreasonable and competitive, he refuses to make peace.

Things got worse after Guy realised that Mikaila a beautiful mixed race lady whose affection he has been trying to win for many months to no avail has a soft spot for Olaniyi. She has been coming around Olaniyi lately and has been refusing her advances. Unknown to Guy, Mikaila is one of the two ladies prepared by Nephilim to carry out his scheme.

Guy is full of rage, jealousy and hatred. He finds it hard to sleep at night and starts feeling depressed. He starts seeing Olaniyi as an enemy he has to eliminate . It is not long after he starts hearing the voice of deception.

He has been contemplating buying a gun for the past week but has never got around to doing it.

But seeing Mikaila talking excitedly with Olaniyi shortly after she refused his persistent attempt at winning her over he begins to 'boil' with rage once again. Olaniyi notices him at a distance and calls out to him in a friendly manner. As soon as Mikaila and Hakeem notice him they also invite him to join their discussion. Without saying a word Guy turns away rudely. He gets into his car and drives home, on his way home that voice says to him again "kill him" but he struggles with it. That voice is persistent and he eventually yields to it, he drives to a well known gun merchants shop where he buys a Glock G17 pistol.

Meanwhile Mikaila has been making attempts to seduce Olaniyi but she has not been successful. For the past few days she has always taken advantage of moments they are alone by talking with the most seductive tone and wearing the skimpiest outfits to his apartment. Olaniyi knows what she wants, it is all for his benefit but he has refused to take advantage.

Tall and elegant with long dark hair, luscious lips and light skinned and spotless she is one of the ladies on campus many men will do anything to be with. It is shocking to her that he has refused her advances for this long.

She carries on her wiles with persistence for another month without any success. What she thought was love for him gradually changed to disdain and hatred, she is not aware that she is under an influence. It is not long before she begins to hear that voice that Guy Chambers was hearing. It is the voice of Nephilim himself.

Her assignment is to divert him from his life's purpose by breaking his focus and tying his soul to hers unlawfully. If she fails at it Nephilim has another agent he has prepared. Nephilim has Jill as a back up plan.

On a Saturday she makes her way to Olaniyi's apartment despite him telling her previously not come around. It is six pm and he just came in from an outing with Guy Chambers and Hakeem, they had a nice time except for a heated argument Guy had over dinner with Olaniyi.

His door bell rings and as he looks through the door hole, Bernice the Persian cat runs to the door as well, Bernice belongs to Philip. Philip is a friend taking the same course with Olaniyi and he has left his cat in Olaniyi's care for a little while to visit his sick and elderly father who stays in another state. Olaniyi reluctantly opens his door for Mikaila, she has a handy basket with her which has a container with some food she made for him. It is a Caribbean delicacy she has always promised to make for him.

She hands him the basket and explains that she wants to fulfil her promise, since this is the only free time period she has time to make the food and bring it over. He politely asks her to come in but she refuses saying she has to go because she has a lot to do. He thanks her for her kindness and stands in front of his door waving to her as she gets into her convertible and drives off. Under the influence of divination and the words of Nephilim she poisoned the dish she made . Her expectation is to hear news of his death by the following day.

He places the dish on a mini kitchen table which he doesn't touch because he had a meal previously.

He reclines on the sitting room sofa stroking Bernice as he sips a can drink and watches CNN news, but he falls asleep after some minutes while Bernice makes her way to the kitchen greedily.

She leaps unto the mini kitchen table and feeds on the dish Mikaila presented to Olaniyi. She ate most of it but before she could finish the meal she slumped off the kitchen table a dead cat. About twenty minutes later wakes up from his short nap to find Bernice dead and the meal almost totally eaten up.

He cleans out the container and wonders if the dish caused the cats death, he takes the body to a nearby acquaintance who is a vet, the vet informs him that Bernice was poisoned by the last meal she had.

Mikaila was shocked to realise by the following day that her intentions didn't materialise, a mixed feeling of fear and guilt comes over her. Intending to ask her a few questions Olaniyi signals to her to come closer, as she walks towards him that Sunday afternoon at an open space where Olaniyi and his friends hang out on Sundays for some fresh air Guy Chambers is some distance away looking through the window of an abandoned building under refurbishment. Under the influence of that voice he intends to kill Olaniyi and get away through an underground passage way of the building . He aims steadily at his target and shoots. Unfortunately for Mikaila and fortunately for Olaniyi she walks over to him to hug him in her guilt. The bullet hits her instead of Olaniyi shattering her skull as she dies in his arms and her brains and blood is spilled on his body and hands. There are screams, upheaval and fear as people run helter- skelter . Olaniyi is speechless, fearful, confused and full of tears as he kneels on the floor with Mikaila's bloody body .

Realising his folly Guy absconds through the underground passage way of the building.

An ambulance pulls over shortly and the police appear. Olaniyi is taken to the nearest police station where he is interrogated while a few other police officers ask the public what they witnessed as the pandemonium continues. After a series of interrogations, searching and investigation that lasts for a week he is acquitted.

Philip arrives a week later feeling very disappointed after hearing the news of Bernices' death. He has always loved and had a sentimental attachment to Bernice ever since his late grand- father presented her to him as a birthday gift three years ago.

Olaniyi ends up buying Philip another Persian cat. The past two weeks has been a tough one, he intensifies his prayer life and tries hard to keep his focus. Things have not worked exactly as Nephilim expected.

Realising that someone was after his life he does his best possible not to exhibit fear or get distracted from his studies as he goes about

his business. Late one night all alone as he was meditating, a pink coloured, circular energy stairs appear in his sitting room and the angels Sirael and Aseyi walk down them through the roof. They speak at the same time 'We have come to reveal to you the person who tried to kill you as we have been instructed by Three the Divine. For the secret of the Lord is with those who fear Him'

With the angels standing several arms length distance to each other, they both point their index finger at the other and a beam of light proceeds from each of their fingers, the colour of the beam of light from Aseyi's finger is black while the colour from Siraels finger is white, both beam of light meet in the middle space between them and forms a huge screen before Olaniyi and the whole scenario of Mikailas antics and death is played out on it as well as the buying of the gun by Guy Chambers and the influence that orchestrated the situation.

Guy Chambers is eventually arrested after a series of investigations that last for two months.

In Nigeria changes are taking place . For so long, Nigeria which touts itself as the giant of Africa has been stifled and plagued with economic instability, civil strife and struggles with its democratic process. After the demise of the three red witches many public officials in Nigeria and Africa who patronise them got indicted in gross acts of corruption and various crimes. They are eventually disgraced out of office.

The gradual change taking place in Nigeria is not enough, there is still so much to be tackled and the citizens of the country are not yet content with the state of the nation. To many of them Nigeria is a mystery.

After the time period of two years Olaniyi finished his post graduate programme. He is extremely excited to be going back to Nigeria, he has missed his parents so much, his darling Amina is also excited he will be around soon.

His trip back home is a pleasant on of over twelve hours, he fills very fulfilled to have achieved his academic aim despite a lot of the challenges designed to break his focus. The future looks bright. He thinks of Makaila who is dead, and Guy Chambers who is behind bars. He paid Guy a visit in prison before travelling . Guy is grateful

he has Olaniyi's forgiveness, he acknowledged he had been a fool and allowed jealousy to get the better part of him. He was very sober and remorseful. The third agent Nephilim used as a point of contact to try and distract and stop Olaniyi is Jill Odaya, Jill is an over -weight, abused African American with the blood of slaves in her veins, she lives with the belief that life is not fair so she does not play fair herself. She is indifferent towards men and her attitude has its root in her unpleasant upbringing, she was unfortunate to be the victim of a forced incestuous relationship that last for many years until her father passed away due to prostrate cancer. She had never forgiven her father, and after a few failed relationships she developed a bitterness towards men. It is the bitterness in her soul that attracted Nephilim to her for his use. She did not succeed at her assignment to take out Olaniyi's life. All her false accusations thereafter failed as well. She eventually ended up in rehab where she is receiving competent help.

At the Airport his parents and Amina have been waiting to welcome him home. As he eventually emerged through the arrival entrance Amina could not contain her excitement as she runs towards him with a shout of joy and hugs him. His parents are extremely glad as they all hug him, get his luggage into the car and head home.

The drive home is a fun one as Amina fills him in on what has been happening while he was away, his parents are at the front seats as his dad drives them them home.

Elizabeth has prepared her sons favourite native meal which he has missed so much. Friends and acquaintances are happy he is back as he meets up with them over a period of weeks.

He starts a new job and begins to do well for himself.

'Nigeria is a paradox, but i have not lost faith in her. I believe Nigeria is going through all she is going through because of the potential she has and Gods plan for her. The enemy always attacks people and nations who have great destinies in God' he tells his fiancée as they sit at the oval shaped dining table one sunny afternoon in his newly rented air conditioned apartment as they discuss issues of mutual interest, one of the topics they love discussing is Nigeria and the way forward for her.

He has always liked discussing with Amina about issues of mutual interest, they enjoy good rappourt. One of the reasons Olaniyi loves her is because he enjoys intellectual discussions with her. She is very intelligent and he is always able to draw insights from her words.

About two years after his arriving in Nigeria Olaniyi set out to start a non- governmental organisation in order to invest in the society and help the less privileged. He and Amina also fixed their wedding date, they have been planning it for over two years now, it didn't happen as soon as they had envisaged previously. Their families are excited, the Hassan and the Benjamin family have been good friends over the years and have been supportive of their children's relationship from the moment they were aware of it.

Their wedding ceremony is an intimate and interesting one . Julius is the officiating minister while his third son Sam plays the role of ring bearer to the new bride and groom. The bride groom and his grooms men are smartly dressed in black suits with white ties and red roses in their button holes, while the bride is beautifully dressed in a v-neck fitted gown, embellished with crystals. Her veil is an antique-styled one which flows past her shoulders. She looks gorgeous, like a beautiful princess out of a Walt Disney movie. There is cheers and excitement in the building when the groom was asked to kiss the bride as the camera man took pictures and joyful friends take pictures with their digital cameras. Amina's younger sister is her chief brides maid while Olaniyi's best man is his friend from secondary school, Alex Uti. Hakeem also graced the occasion, wearing a black suit and bow tie to match.

The reverend Julius gives a befitting admonition on the power of love and its importance in the family institution. He also talked about the power of words and its effect on marriage. 'Your relationship started with words and it is the words you have spoken to each other since you met that has brought about this ceremony. Do not ever stop speaking words of love to one another in order to have a successful marriage' He turns to the groom and informs him that he is called a bride-groom on this day because it is believed that he has been grooming his bride with the right words as Christ grooms the church washing it with the water of the Word. He encourages him to continue doing so, not to let it stop after their wedding day.

The bride and groom are beaming with smiles and wave as the crowd outside the church let out a roar of cheering and applause. The celebration at the reception hall turns out to be colourful, the hall is alive with radiant colours. You can literally touch the pomp and feel the pageantry as guests turn out in all sorts of beautiful attires. The women are noticeable in their native attires and uniquely tied head gears. The presence of a guest artist who played brought a lively mood to all.

There is a lot to eat, professional caterers see to it that everyone is fed and have enough food and drinks. With the success of their wedding day and the joy of their dreams coming true the newly married couple settle down to a marriage that lasts for the rest of their lifetime on earth. A marriage of joy and peace.

But with some passage of time the plight of Nigeria and Nigerians come to Olaniyi's attention all over again. He knows Nigeria is not yet where it should be.

Understanding the destiny of Nigeria is at stake without competent, compassionate and intelligent leadership and realising there is a limit to which he can influence and alleviate the living condition of Nigerians through his charitable giving Olaniyi decides to get involved in Nigeria's political process. Like a skilled works man he starts off by mapping out a seven year strategy that will put him at the helm of affairs.

Charitable giving, writing through the print media on the state of the nation and the way forward, supporting sports, educating people through free lectures and the distribution of illuminating materials, forming a political party, political networking, receiving political mentorship and annual fund raising parties for the needy.

As he dedicates himself thoroughly to these plans over the seven year period, his fame spread rapidly throughout Nigeria.

He continues with his bi annual charitable giving and starts the annual fund raising party which is a major fund raiser for the needy. These events bring him into favour with society bigwigs.

Realising that there is nothing that brings Nigerians together more than sports he begins to invest heavily in sports from the national team to Nigeria's football clubs. He begins to have a pride of place among sport loving Nigerians.

As he begins to write about Africa, Nigeria, its spiritual and political terrain and the way forward for Nigeria in columns with three different national newspapers his writings bring him to the awareness of Nigerians that he is a man who understands Nigeria's issues and has insights for Nigeria's advancement.

Together Olaniyi and Hakeem start a politically educative arm through their charitable non- governmental organisation through which they educate Nigerians on the way forward and the kind of leader Nigeria needs. Through indoor teaching in a rented hall and distribution of published articles, they inform the people that Nigeria's primary problem is a leadership problem. The educative segments are a success as lots of people gravitate towards it. Politicians who like what the young men are doing come around to enquire about it, some become part of the programme. Through some of them Olaniyi and Hakeem receive political mentorship.

They continue to talk, organise and enlighten people to see what is right not only for them but the generation next.

Seven years has gone bye and with the next presidential elections a year away, Olaniyi sets himself aside from work and family to hear what the Divine has to say on the matter. After careful observations, seeking advice, and deep thoughts Olaniyi and Hakeem sense the time is right to start a political party that is new on the scene which will give Nigerians new hope politically. A party that will raise the bar and the standard of excellence.

Together they form the Peoples Pride Democratic Party with the acronym PPDP.

Their campaign slogan is 'people first'. The PPDP team know that any nation that puts its people first will be blessed by God. Most of their supporters are the people and friends they won over the last seven years, men and women they succeeded in winning over to their way of thinking and those who previously share their political and economic ideologies. Together it is their hope that the deserts of despair and hopelessness that has taken over the economic and political landscape of Nigeria will be converted to fertile regions of prosperity.

Already pushed to the wall and ready for a revolution a lot of the PPDP supporters are men and women who have been adequately

informed that it is from the blood of martyrs the flowers of revolution blossom. They know freedom has a price and they are ready to pay it. Many are even ready to die. They know that to die a martyr is to pump blood in the veins of society.

They have been encouraged to know that God helps the bold and fear is what turns people into cowards.

The PPDP grew into a phenomenal movement in Nigeria.

Two moths to the presidential campaigne Olaniyi declared his colleague and good friend Hakeem to the public as his running mate. They have their posters banners and hand bills released to the public. They also put up a few television adverts and radio gingles.

The campaigne starts. The competition is for the votes of over one hundred and fifty million Nigerians between fifteen political parties with candidates from different regions of the country with different ideas and beliefs about how to move the country forward.. Some are ex-governors, two ex-presidents, senators, business men and a few fresh faces which include Olaniyi and Hakeem.

It is a long and competitive campaign among the political parties, some of the finest minds on the Nigerian political scene are involved on the campaign trails with each politican trying to win the affection of the populace. There are series of debates lined up for the aspirants. It is also the most colourful and innovative Presidential campaign Nigeria has ever know. The world watches with keen interest as Sky and CNN cover the campaign. Most of the debates are streamed live on the internet.

Olaniyi Benjamin is a fine speaker with some of the best ideas and policy, he speaks with authority and conviction at each venue and the crowds respond to him with enthusiasm. Most of the youth see him as the face of a new Nigeria. It is no surprise considering he has the backing of almighty God, the divine. Besides, he is the youngest of the Presidential aspirants. Different issues from the place of Nigeria in the modern world, importing and exporting policies, diplomacy, education and commerce are some of the topics debated.

Apart from hired security services who guard Olaniyi and his running mate and co-founder of the Peoples Pride Democratic Party Hakeem, the angels are always on guard protecting them from the evil of men in the spiritual realm. One sunny day as he is speaking at a

well known town hall at the eastern part of Nigeria in Enugu with the Nigerian television authorities, SKY, CNN and a host of local media houses covering the event a hired assassin some how made it through the security check. He stood up, brought out a pistol and shot at Olaniyi who is on stage giving perhaps one of his best speeches which is about his vision for the people of the eastern part of Nigeria and how he intends to develop eastern Nigeria and make it the innovative, inventive and technological arm of Nigeria. The crowd is in disarray and security act promptly to get the assassin arrested. He does not mind as long as his target is dead. As the bullet accelerates through the air it stops right in front of Olaniyi's face and lands on the stand right in front of him. Without being ruffled or moving for cover he confidently picks up the bullet with his fingers. It is the angel Sirael who caught the bullet with his fingers before it could shatter Olaniyi's skull. He invisible to everyone around except Olaniyi. Olaniyi smiles to his angel friend and quietly wispers a thank you. Nigerians and the international community are shocked! His fame spreads globally and media houses and tabloids make it their major news the following day.

Some begin to see him as a demi-god although he never demands worship and rejects such compliments. His profile begins to rise and he is head and shoulders above other contestants at the polls. The PPDP team network effectively. With Hakeem and a large group of the team focusing on the northern part of Nigeria, he speaks the native language of that region well so he is able to connect with the people. Olaniyi and another part of the team focus on the south south of Nigeria. They have a well organised campaign as Olaniyi and his team criss cross all the thirty six states.

Opposing parties start scheming as they try to use political ploys to weaken the PPDP and defeat the PPDP's entire agenda for change and progress in Nigeria. Many of them resort to spending large sums of money on negative adverts and all sorts of smear campaigns with the intention of making the popularity of the PPDP wane and one another. It will not work as many of them hope.

The day arrives for the citizenry to exercise their votes. People vote. The Divine put their blessing on the day, and it turns out more peaceful than the 'powers' that be thought it would. Business men

and politicians who have been benefitting from the status quo, the enemies of change did their best to frustrate the effort of the voters all to no avail. When many of them realised the efforts of their thugs and agents were not working as planned and after seeing the 'handwriting on the wall' that their candidates might lose they resorted to disturbing the voting process by toying with the atmosphere and elements so that many people will not make it to the voting centres in order to cause distruption. They consulted rain makers, men who have a mysterious and diabolical way of tampering with the atmosphere and making it rain at places and times when nature does not call for it. As the contracted rain makers brought out their ancient charms, amulets and oracles and started incanting from various locations even on mountain tops, the weather begins to change and dark clouds begin to appear in the sky as the wind begins to blow signifying it is going to rain. But just before drops of rain fall the sun appears with rays of light bursting out through the dark clouds as the sun shines in its intensity.

This happened a few times but the sun keeps reappearing dispelling the dark clouds and putting an end to a rainy weather. The rain makers are frustrated and conclude that they should not force things. "This is the finger of God" they say to themselves. Contrary to their expectation people went out in masses to vote.

People and parties who are up to no good try to rig the elections and deny Nigerians of their constitutional right, unfortunately for them steps had been taken by the electoral commission out of experience to make sure the ballot boxes are fixed ones, because they are immovable no one could change the votes of the people.

Mr Olaniyi Benjamin won the presidential election with a distance of ten thousand votes to his runner up.

# Chapter 5

# LIBERATION

Three months after the result of the election Olaniyi Benjamin is to be sworn in as the new president of Nigeria with a lot of pomp pageantry and a street parade, his triumph is an inspiration to all and the joy of his success spreads to all and sundry. In the spiritual realm there is jubilation as the host of heaven rejoice for the continent of Africa especially the nation of Nigeria which is the crown jewel of Africa.

The People's pride democratic party won seats in most states across Nigeria.

The captivity of Nigeria has been turned. It is the set time to favour the continent of Africa and show case the beauty of Nigeria to the rest of the world.

Like a ripples effect sons of the covenant will begin to take their place in various fields of industry, the powers hindering their rise as been taken out of the way. It is time for the fulfilment of promise to the man of Nubian race. Olaniyi's rise and ascension spiritually and politically is a sign. His pattern of success will be duplicated across Africa at the leadership level. A cleansing has begun in the African continent.

The night before his swearing in ceremony there was a celebration party held at the banqueting hall of the Hilton hotel in Abuja by members of the Peoples Pride Democratic party. There was a flow of champagne, the most exotic names in wine and lots of delicacies to eat, thanks to Flavio Fernandez and his team of dedicated staff, he is Italian, an extraordinary chef and staunch member of the Peoples Pride Democratic Party who has been running a food packaging and catering company in the heart of Nigeria for the past ten years.

As Olaniyi and his wife call it a day and head to their hotel room, he sees the angels Sirael and Aseyi glide along beside their car. To the right side of the car there is a mini-sized Nigerian flag attached to the front of the black coloured bullet proof Mercedes benz and to the left side there is another mini flag which has a white background with the logo of the Peoples pride democratic party in its middle. His wife and the driver do not see the angels. On the left hand side of the car is Sirael gliding protectively with his left hand firmly on the handle of his Makaira and his right hand holding onto the sheath of his sword. He is postured like he is ready for battle, Aseyi maintains the same position as Sirael. As Olaniyi looks to the right through the car window Aseyi gives him a thumbs up and he smiles back at the angel. Tired as a result of the activities of the day, they went straight to bed and enjoy a good nights sleep.

In the early hours of the morning of his Presidential inauguration the angels appear in his hotel room while his wife is fast asleep. 'Greetings' they both chorus at the same time in their calm but majestic voices. 'We are here to remind you that you have nothing to fear as you take on this new position as the President of your country, God has brought you this far and He will not fail you. His hand is upon you for good things. But be warned pride operates in a subtle way and you must not let it into your heart. The reason you have been chosen for this position is to take care of Gods people and to bring Gods inheritance out of the doldrums. Be strong and courageous. We will be with you' . Then they turn invisible.

It is the twenty ninth day of May of the year two thousand and forty five. At twelve mid day, Olaniyi Benjamin is sworn in as the President of the federal republic of Nigeria at the age of thirty seven in the capital city of Abuja in the presence of the previous president and his

deputy, members of his political party, friends, and the well wishing public who seem very excited.

He goes ahead to make a befitting thirty minutes speech that shows the gratitude he has to the voters for giving him the opportunity to serve, he talks about the bright future he sees for Nigeria and what Nigerians can expect from him and his vice president and the ministerial team they will appoint shortly. He articulates the style of leadership he intends to effect and informs the public that his aim is to serve and his motivation is to lift the country to greater heights as God enables him. He promises transparent leadership which seems to have eluded the country for so long.

The cheerful audience respond with a standing ovation.

The evil realm is disappointed as the 'gods' of Africa lose their grip over the great continent. Disappointed, the dark Lord banishes his chief principalities Horns, Nephilim and Apollyon into prisons of darkness for a time and seasons for failing in their assignments over Africa.

Over the next eight years the economy of Nigeria and its technological and infrastructural development will develop faster than any other developed country. Rapid growth and development start taking effect in the tourism and entertainment industries of Africa during the period. Nollywood, Nigeria's film industry develops rapidly and holds a pride of place among the worlds cinema industry. African nations will flourish rapidly in the years to come, the intelligence department of African countries begin to grow, intellectual and brilliant men will start to hold diplomatic positions, men who will become spectacles to angels and 'new life' will come into the educational sector.

In the near future witty inventions and rare discoveries are made by Africans, for she who was barren has now become a mother of many children.

An angelic portal has opened over Africa. In the near future a Nigeria that changes the world emerges, it transforms into a country with flying cars, architecture masterpiece with some of the buildings as high as two hundred floors, robots that serve in public and rails in the sky.

A new world power is on the horizon.

Indeed the future of the motherland is glorious.

# MEANINGS

Alake – is the traditional ruler of the egba clan of Yorubas in the city of Abeokuta in south western Nigeria

Abeokuta – is the largest city and capital of Ogun state in south west Nigeria.

Yorubas – are one of the largest ethnic groups in west Africa and speak the Yoruba language.